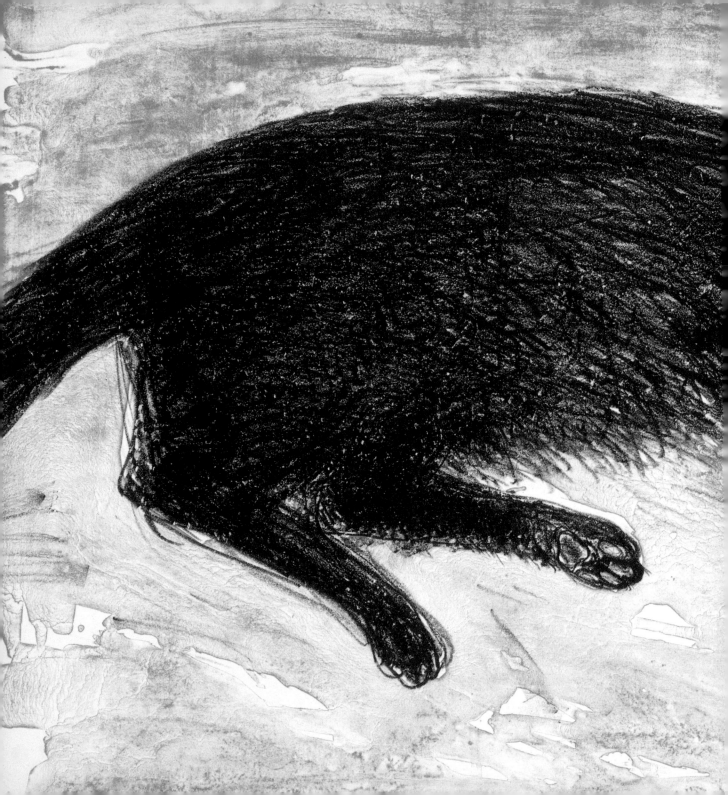

V&A Cats

Introduction by Beryl Reid

V&A Publications

Text compiled by Michael Wilson

First published by V&A Publications, 1989
Reprinted 1998, 2000

V&A Publications
160 Brompton Road
London SW3 1HW

(c) 1989 The Board of Trustees of the Victoria and Albert Museum

ISBN 1 85177 056 9

A catalogue record for this book is available from the British Library.

Designed by Chrissie Charlton & Company
Jacket design by Avril Broadley
Picture research by Lesley Burton and Celestine Dars

Printed in Hong Kong

Jacket and title page illustration:
Elizabeth Blackadder, *Black Cat*, 1985.

From the Renier Collection c. 1920

CONTENTS

▲▲▲

Peek Frean Biscuit Advertisement c. 1900

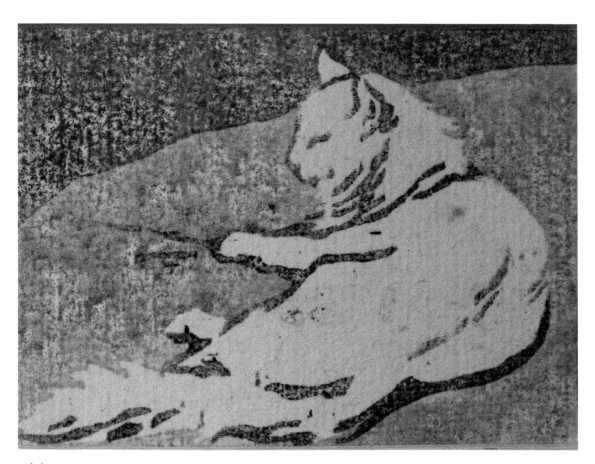

Ethel Mars *The White Cat* c. 1910 Watercolour

MY CATS

▲▲

BERYL REID

I have always had a cat in the house. When I was a girl we had Hamish and Jumbo. I used to do an impression of my mother calling Hamish in at night: 'Come along Hamish, that's the good boy'. He would look down from the fence with a look of amused disdain. 'You arc not a bit like your mother, you fool', He'd smirk, and would not move a paw.

Today my house is home to eleven cats. It's called Honeypot Cottage and it is a wonderful sort of house with the most marvellous river frontage. All the rooms are round and all the domes thatched. Round houses may be quaint, but they are not an ideal shape. However, I loved the cottage when I saw it although everyone thought I was slightly barmy because it was in a dreadful mess, with dry rot in the bedroom and wet rot in the kitchen. I was between weddings when I bought the house but pretty soon I married Derek and it became our home, and home for our cats.

In the beginning there was Footy. Footy was born in the straw surrounding the water tank on the roof. One day we heard crying and found Footy and her three brothers and sisters anxious, hungry and alone. We had no idea where their mother was, or whether they had been abandoned. We brought them down to the shed. After a while their mother did show up. We called her Ella because she had a sexy walk like Ella Fitzgerald. She was very wild and because we touched her babies she destroyed three of them. Which left Footy.

She was an absolutely adorable kitten with lovely long black hair. We had the sort of relationship you have with a

dog, very much one to one. She had an uncanny knack of predicting my movements. Once, when I went to Cornwall for four days she went missing, but nobody dared tell me. Just before I returned she strolled back, and when I walked up the garden path there she was, smiling seraphically, as if nothing had happened.

I learned a lot about cats from Footy. Much of what they do is not instinctive, but learned from their mother. If mother disappears when they are babies, as Ella did, basic habits like cleaning themselves don't get taught. Footy, for example, had knotted knickers, because nobody had taught her to lick herself clean. One day the vet came to de-knot Footy. Footy thought this about as much fun as a poke in the eye or a cold shower and vamoosed. I was frantic. I ran out under the front step and shouted 'Come back Footy, come back wherever you are, I love you, I love you!' A terrified milkman stood in front of me. He shoved two bottles in my hand and ran. I wonder who he thought Footy was.

During the filming of *The Killing of Sister George* I used to lunch at a hotel called, I think, the Swan. One day into the dining room strolled a dear little black cat with white feet and a white chest. I was cooing over her when the owner of the hotel said she had got one kitten left and would I like it. 'Desperately', I replied, and of course I called her Georgie Girl. She had a peculiar trait. She either loved or hated my singing. Whenever I sang she'd crawl over my head and bite my ears. I never really knew whether she was overcome by joy or frantic with horror.

Thinking that she would be lonely, I got another kitten, Andy. Kittens are always happier when there are two of them, they like to sleep, eat and play together. Andy and Georgie loved each other very much. Andy was a bit thick though. One problem he had was judging distances. He'd bump into things. Most cats with a few marbles can do things like jump, but Andy would have to practice before he could even

attempt a small sally. I used to watch him in the garden practising very small jumps, until he could attempt only a *fairly* small jump. A small step for most cats but a giant leap for Andy. Simple he might have been, but like a lot of daft folk he had a lovely nature.

One day I was walking along the road near the village when I heard crying behind the hedge. There lay two tiny kittens, abandoned and starving. I called these two little tabbies Partick and Emma. Patrick was named after the suave English actor, Patrick Cargill. Emma was one of the most charming cats I have ever known. Patrick was very much king of the castle. Not the most beautiful creature in the world, a grey and white tabby, he had outsize ears and feet and had a passion for eating roses. If I put a vase of flowers in the house he would pick out the roses and eat his way through the lot. He also loved cabbage stalks.

I became very friendly with a Muscovy duck whom I christened Jemima. She was the same colour as Patrick, white and grey; they became great buddies. When she arrived she had three little babies. She was a dear little thing or rather a dear big thing, being bigger than Patrick at the time. Jemima kept her babies in the bushes. When Patrick found out where the babies were holed up he though it would be a very nice idea to eat them. So off he toddled to the bushes in search of a modest feathered snack but Jemima rumbled him. As his bottom poked out of the bushes Jemima would peck it unmercifully. Poor Patrick's bottom got very sore. I bought some healing ointment but there was nothing I could do because Patrick regarded his bottom as private property, a no-go area, with access strictly *verboten*. In the end the three little ducklings died of a liver complaint, and this seemed to bring Patrick and Jemima closer together. They had a common bond, a common grief. Jemima was mourning for her loved ones and Patrick for his lost dinner.

Jemima decided to start again and so she laid some eggs.

Ducks generally are not overburdened with brains but Jemima was considerably underburdened. She laid her eggs on my coal. She picked all the down out of herself and made a rather pathetic and fragile nest in the midst of all those black lumps. When a duck is sitting on eggs they have to wet their feathers twice a day. When Jemima swanned off to the river for a quick dip Patrick would sit on the eggs for her. But cats were not designed to sit on eggs, particularly big loving cats like Patrick. They are too heavy and so the eggs never hatched. One day Jemima got so angry at the lack of progress that she broke them all, all nineteen.

Despite being a complete failure as a surrogate father, Jemima really loved Patrick, and they remained very much husband and wife. They decided to have another go and this time she chose a mildly preferable spot under the front steps. Not brilliant but less combustible. Patrick, ever helpful, sat on this lot too with the same results. Another nineteen duff eggs. She should have stuck to her own kind but feathers and fur were clearly all the same to Jemima

A little while ago I decided I was getting rather short of boys, so I called Muriel Carey, my friend at the RSPCA, and she said she'd bring a couple of kittens along. She popped over with a basket, but knowing I was a soft touch she'd smuggled another one under the lid. This was Muriel, an old English tortoiseshell long haired cat. She is a great beauty. Her only failing is her equilibrium, she falls off the television all the time. One of the others she came with was a lovely tabby called Sir Harry after Sir Harry Secombe, who become devoted to her. I used to wonder what the neighbours thought when I shouted of a night, 'Sir Harry, Sir Harry come in and come to bed!'.

One weekend two friends were staying, Terry and Olivia. I heard Terry say, 'I haven't seen Beryl all morning', and Olivia looked across at me and said, 'I can just see her moving dimly'. The unnamed cat I had in my

Scrap c. 1920
Colour lithograph

hands at the time was immediately christened Dimly. Dimly is a great adventurer. He is both brave and fool hardy. I was skipping lightly to the loo one day when Dimly beat me to it. He shot through the door and underneath me and hit the porcelain bowl with such a crack that he knocked himself out. I dragged him out and then thought – how do you give a cat artificial respiration? If it is a person you lie them on their face, push down on their back and the water shoots out of their mouth. I decided to squeeze his ribs and see what happened. The water spurted from his mouth and he woke up soaking wet and bewildered. I wrapped him in a towel and he sat there totally bemused for a day and a night.

Sometimes he thinks he's a lumberjack. When the stream outside my house rises above the bank Dimly loves to jump on willow logs floating by, putting his feet either side and paddling happily along. Of course, what always happens is that the log rolls over with Dimly on it. Cats are marvellous swimmers and if brought up near water love the stuff. So Dimly will swim to the shore, shake off a bit of the river, and return to the fray. All my cats fall in to the river from time to time but never come to any harm.

Sometimes I'm a bit of a social worker. Elsie had a very unhappy time in Bristol before she came to me, and for the first few months was always hiding under cars. She's fine now and has taken up a career as a breakdancer. I think she must be quite old so her agility is the more remarkable. She is a very happy cat. I have four ginger cats, Billy and Clive, who had a miserable childhood, and Paris and Tufnell, who are twins. Billy likes to run all over me in the morning and if it's wet, he dries his claws on my chest and a lot of great boulders fall out because his claws are so enormous and he covers me with mud pies. Paris never walks in to a room, he slinks. I call him Snake Hips Johnson. If I say 'Hello there Paris' he falls to the ground and rolls on his back and demands a cuddle or a tickle. I have a black kitten called Snowball and a new one

called Fleur. She used to be the cat at the Lyric Theatre and when I did *Gigi* I asked to have her but the boys who worked there wanted Fleur to stay. However, a few weeks ago they relented and here she is, no longer the skinny little thing she once was, happy and affectionate.

If you watch a cat relax you can only be filled with envy. To be able to put away all anxiety and fear, to bury past and future, to stretch and yawn and surrender to the pleasure of the present is a wonderful gift. Their ease is infectious. When I stroke a cat and hear its purr I am at peace.

This is a beautiful anthology which will have a permanent place by my bed. The stories and poems and memories in these pages are a perfect reminder of feline gentleness and humour. For me, as for these artists and writers, happiness is a life and a house full of cats.

Beryl Reid
Wraysbury
1989

FAMOUS CATS

▲▲▲▲▲▲▲▲▲▲▲▲▲▲▲▲▲▲▲▲▲▲▲▲▲▲▲▲▲▲▲▲

Christmas card
c. 1895
Colour
lithograph

BUSTOPHER Jones is *not*
skin and bones –
In fact, he's remarkably fat.
He doesn't haunt pubs – he has
eight or nine clubs,
For he's the St James's Street Cat!
He's the Cat we all greet as he
walks down the street
In his coat of fastidious black:
No commonplace mousers have
such well-cut trousers
Or such an impeccable back.
In the whole of St James's the
smartest of names is
The name of this Brummell of Cats;
And we're all of us proud to be
nodded or bowed to
By Bustopher Jones in white spats!

His visits are occasional to the
Senior Educational
And it is against the rules
For any one Cat to belong both to
that
And the *Joint Superior Schools.*

For a similar reason, when game is
in season
He is found, not at *Fox's*, but
Blimp's;
But he's frequently seen at the gay
Stage and Screen
Which is famous for winkles and
shrimps.
In the season of venison he gives his
ben'son
To the *Pothunter's* succulent bones;
And just before noon's not a
moment too soon
To drop in for a drink at the *Drones.*
When he's seen in a hurry there's
probably curry
At the *Siamese* – or at the *Glutton*;
If he looks full of gloom then he's
lunched at the *Tomb*
On cabbage, rice pudding and
mutton.

So, much in this way, passes
Bustopher's day –
At one club or another he's found.

It can cause no surprise that under
our eyes
He has grown unmistakably round.
He's a twenty-five pounder, or I am
a bounder,
And he's putting on weight every
day:
But he's so well preserved because
he's observed
All his life a routine, so he'll say.
And (to put it in rhyme) 'I shall
last out my time'
Is the word of this stoutest of Cats.
It must and it shall be Spring in
Pall Mall
While Bustopher Jones wears white
spats!

T. S. ELIOT 1888–1965 *Bustopher
Jones: The Cat about Town* from *Old
Possum's Book of Practical Cats*

'THREE little mice sat down to spin,
Pussy passed by and she peeped in.
What are you at, my fine little men?
Making coats for gentlemen.
Shall I come in and cut off your threads?
Oh, no, Miss Pussy, you'd bite off our heads!'

BEATRIX POTTER, 1866–1943 *The Tailor of Gloucester*

TIDDLES the cat is lord of the ladies' loo at a London rail station.

The 11-year-old orphan has lived in Paddington ladies' toilet all his life. And he gets fan mail from all over the world.

Tiddles considers himself a very important pussy, living it up on steak, lamb and cod. He's as fat as a football, weighing 30lbs.

But Tiddles of the ladies' is no gent.

His favourite trick is squeezing under the loo doors to give people a fright.

'He squashes himself flat and squeezes himself under,' said Gloria, who works in the loo.

Tiddles is looked after by June Watson, who has worked in the loo for 18 years.

'He throws his weight around here. He thinks he's lord of the loo,' she said.

The Evening Standard

WILBERFORCE, the stray cat which 'served' four Prime Ministers at Downing Street over a period of 14 years, died in his sleep today. Mrs Thatcher was saddened by the news, which was given to her at the end of the morning Cabinet meeting.

The cat renowned as 'the best mouser in Britain' was introduced to Downing Street in 1973, when Edward Heath was Prime Minister, to resolve the mouse problem in the corridors of power.

A year ago, Wilberforce retired to a private home in the Home Counties. Mrs Thatcher's farewell gift was a tin of pilchards she had bought especially for him in a Moscow supermarket.

The Evening Standard

CLIFFORD·LEES.

'PLEASE would you tell me,' said Alice a little timidly, for she was not quite sure whether it was good manners for her to speak first, 'why your cat grins like that!'
'It's a Cheshire cat,' said the Duchess, 'and that's why. Pig!'
She said the last word with such sudden violence that Alice quite jumped; but she saw in another moment that it was addressed to the baby, and not to her, so she took courage, and went on again: –

'I didn't know that Cheshire cats always grinned; in fact, I didn't know that cats *could* grin.'

'They all can,' said the Duchess; 'and most of 'em do.'

'I don't know of any that do,' Alice said very politely, feeling quite pleased to have got into a conversation.

'You don't know much,' said the Duchess; 'and that's a fact.'

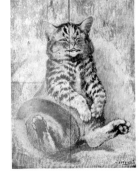

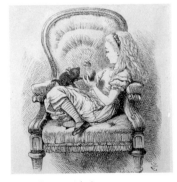

Louis Wain, 1860–1939
Laughing Cat c. 1910
woodblock

Sir John Tenniel 1820–1914
Alice and the Black Kitten

'IN *that* direction,' the Cat said, waving its right paw round, 'lives a Hatter: and in *that* direction,' waving the other paw, 'lives a March Hare. Visit either you like: they're both mad.'

'But I don't want to go among mad people,' Alice remarked.

'Oh you can't help that,' said the Cat: 'we're all mad here, I'm mad. You're mad.'

'How do you know I'm mad?' said Alice.

'You must be,' said the Cat, 'or you wouldn't have come here.'

Alice didn't think that provided it at all; however, she went on. 'And how do you know that you're mad?'

'To begin with,' said the Cat, 'a dog's not mad. You grant that?'

'I suppose so,' said Alice.

'Well, then,' the Cat went on, 'you see a dog growls when it's angry, and wags its tail when it's pleased. Now *I* growl when I'm pleased, and wag my tail when I'm angry. Therefore I'm mad.'

'*I* call it purring, not growling,' said Alice.

'Call it what you like,' said the Cat.

LEWIS CARROLL, 1832–1898 *Alice in Wonderland*

Old Mike! Farewell! We all regret you,
 Although you would not let us pet you;
 Of cats, the wisest, oldest, best cat
This be your motto – Requiescat.

Mike guarded the main gate of the British Museum from 1909 to 1929.
F C W HILEY, MA *Assistant Keeper in the Department of Printed*
Books in the British Museum.

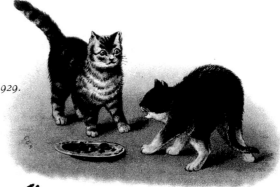

The visitor was a neighbour, Mrs Ribby; she
 had called to borrow some yeast.
 Mrs Tabitha came downstairs mewing
dreadfully – 'Come in, Cousin Ribby, come in, and sit ye
down! I'm in sad trouble, cousin Ribby,' said Tabitha,
shedding tears. 'I've lost my dear son Thomas; I'm afraid the
rats have got him.' She wiped her eyes with her apron.

'He's a bad kitten, Cousin Tabitha; he made a cat's cradle
of my best bonnet last time I came to tea. Where have you
looked for him?'

'All over the house! The rats are too many for me. What a
thing it is to have an unruly family!' said Mrs Tabitha
Twitchit.

BEATRIX POTTER 1866–1943, *The Tale of Samuel Whiskers.*

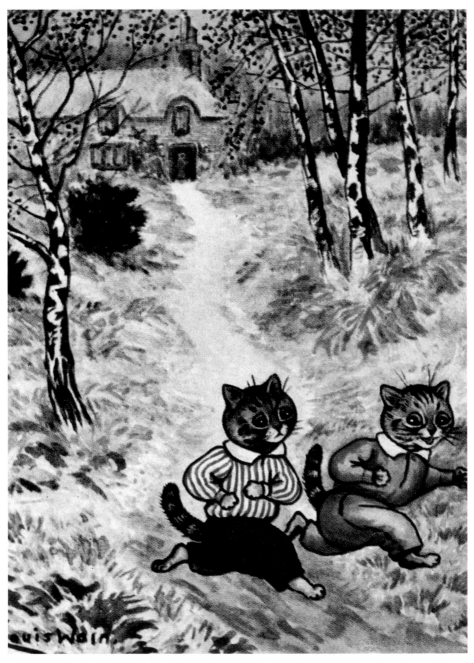

Louis Wain c. 1910 Print

ODD OWNERS
AND ECCENTRIC FANS

▲▲

A whole book could be written on the joys and pitfalls of cat-boarding, although in the main the problems that occur are not with the cats themselves but in our dealings with their owners. We do not board entire males unless they are registered studs, and then they have special accommodation. The general public have many and varied terms for the altering of cats, be it castration in the case of the male or spaying in the case of the female. Our booking forms taken from the 'funny file' include under the entry for *Sex* 'muted', 'sprayed', 'nurtured' and 'castigated'. The forms also include space for *Favourite Diet* and entries range from tripe, lights and giblets to Mediterranean prawns (a cat from sw3) and, in one case, *Spaghetti Bolognaise* for a cream colour-point known as Gobbley who, to our amazement, when presented with this dish, proceeded to suck in the spaghetti by the yard with great aplomb. Other cats have more conservative tastes, liking 'anything so long as he sees it comes from your own plate' to 'early morning tea, with sugar'.

MIKE SAYER, *The Cat-Lover's Bedside Book* 1974

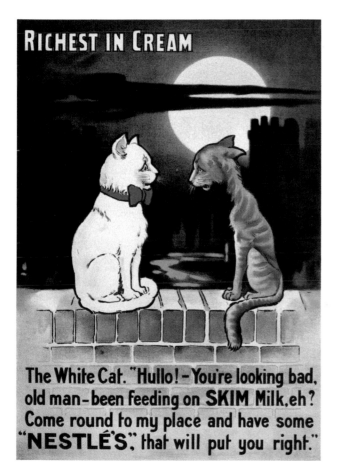

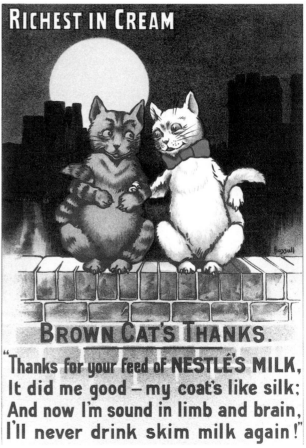

Nestlé advertisement c. 1920 Colour lithograph
Reproduced by permission of the Nestlé Company

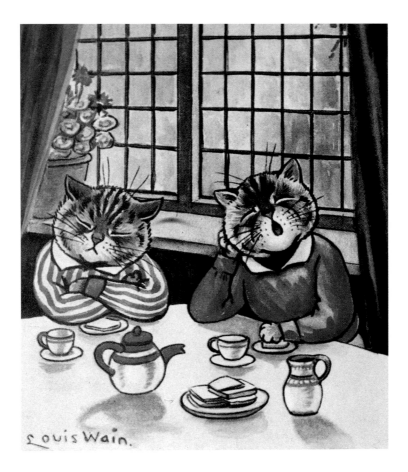

Louis Wain c. 1910 Print

IN drawing my cats, I always commence by drawing the ears first; *in every case I do this*, and if I try any other way the proportions are certain to go wrong. Why, I do not know. Whether it is mere habit, and I have grown into it as a habit difficult to break, or not, it remains the same; any unsatisfactory work comes when the ears have not been the first keynote of the drawing.

LOUIS WAIN, 1860–1939

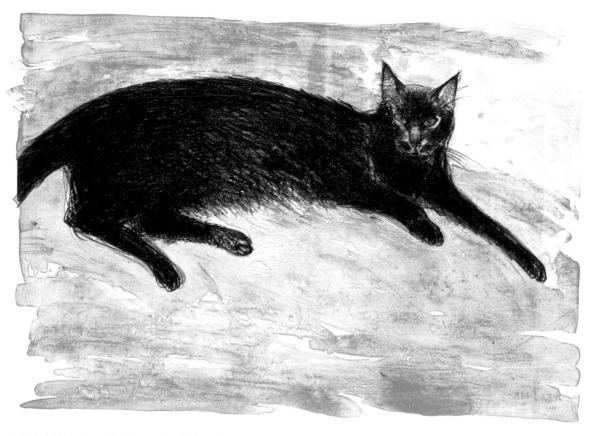

Elizabeth Blackadder *Black Cat* 1985 Lithograph

WHEN I was young, no public man would have dared acknowledge himself a cat enthusiast; now even MPs can do so without danger of being laughed at.

LOUIS WAIN, 1860–1939

IN the autumn of the year 1803, when I entered upon this place of abode, I found the hearth in possession of two Cats, whom my nephew Hartley Coleridge (then in the 7th year of his age) had named Lord Nelson, and Bona Marietta. The former one was an ugly specimen of the streaked-carrotty, or Judas-coloured kind; which is one of the ugliest varieties. But *nimium ne crede colori*. In spite of his complexion, there was nothing treacherous about him. He was altogether a good Cat, affectionate, vigilant and brave; and for services performed against the Rats was deservedly raised in succession to the rank of Baron, Viscount and Earl.

There are still some of Lord Nelson's descendants in the town of Keswick. Two of the family were handsomer than I should have supposed any Cats of this complexion could have been; but their fur was fine, the colour a rich carrot, and the striping like that of the finest tyger or tabby kind. I named one of them William Rufus; the other Danayr le Roux, after a personage in the Romance of Gyron le Courtoys.

ROBERT SOUTHEY, 1774–1842

STRAY cats which his wife insists on keeping have driven Mr Stanley Appleby from his comfortable bungalow into a twin-berth caravan in his garden.

His wife, Freda, 45, started her interest in cats 15 years ago when Mr Appleby bought her a black Persian cat for company.

Within two years Mrs Appleby began taking in strays and cats from a corporation refuse site near their home in Pickering, North Yorks. her feline family has now grown to 59.

One by one the rooms in their cosy home were given over to the exclusive use of dozens of cats and kittens until Mr Appleby, 55, decided he had had enough.

Mr Appleby, a shift worker in a plastics factory who keeps his own cat in the caravan, said yesterday: 'I couldn't sleep, relax or sit in comfort when I came home from work.

'Freda is happy with her cats so we came to this compromise whereby I would live in the caravan and she would have all the space she needs to feed and exercise them.

'Although she knows I don't completely agree with the situation, we are still the best of friends.'

The Yorkshire Herald

IN strictest secrecy I've heard
And promised not to say a
word
About a certain Lady's age,
Her name and face and parentage;
This Lady had a Cat whom she
Adored quite immoderately;
For his amusement once, her whim
Invented a disguise for him.
With tresses cleverly attached,
And precious earrings nicely
matched,
The Cat's head she adorned, then
she
Regarded him admiringly:
About his neck she hung fine pearls
Larger than the eyes of Merles;
A fine, white, laundered, linen
shirt,
A little jacket and a skirt,
A collar and a neckerchief
Made, with the help of her belief,
Old Tomcat into Damsel gay.
Not quite a beauty,
But adequate, at least, to stir
The Dame who'd decorated her.
Then up before a looking-glass
The Lady held this darling lass:
This Cat who showed no evidence
Of being surprised, or of pretense

At joy for being by fool caressed,
Or seeing himself an Idol dressed.
Whatever happened then took place
Because she failed to embrace
Her Cat as closely as she might.
Without considering wrong or
right,
The good Cat gained the stair,
And then the attic, and from there
Out upon the tiles he strayed;
Loudly crying, the Lady prayed
Her servants instantly to be
Out after him assiduously:
But in the country of the tiles
Wary Tomcats show their wiles.
They searched for him until they
tired,
And the next day they enquired
Of the neighbours; some averred
They couldn't credit what they
heard,
Others their belief asserted;
All were very much diverted;
And all the while the Cat uncaged
Never returned; the Lady raged
Less for the necklace's expense
Than for her Tomcat vanished thence.

PAUL SCARRON, 1610—1660

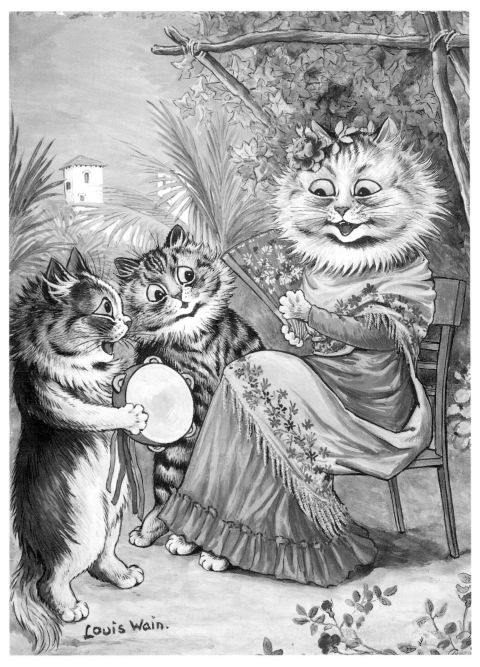

Louis Wain *In Sunny Spain* c. 1910–20 Print

A Peep into Catland illustrated by Constance Howell 1890

D
R. BARKER kept a Seraglio and Colony of CATS, it
happened, that at the Coronation of George I. the
Chair of State fell to his Share of the Spoil (as
Prebendary of WESTMINSTER), which he sold to some
Foreigner; when they packed it up, one of his *favourite* CATS
was inclosed along with it; but the DOCTOR pursued his
Treasure in a Boat to GRAVESEND, and recovered her safe.
When the DOCTOR was disgusted with the *Ministry*, he gave
his *Female* CATS, the Names of the *chief Ladies* about the
COURT; and the *Male-ones*, those of the *Men in Power*, adorning
them with the *Blue*, *Red*, or *Green* Insignia of RIBBONS, which
the Persons they represented, wore.

THE REV. W. B. DANIEL, *Supplement to the Rural Sports* 1812–1813

From the Renier Collection c. 1910

ITEM: I desire my sister, Marie Bluteau, and my niece, Madame Calonge, to look to my cats. If both should survive me, thirty sous a week must be laid out upon them, in order that they may live well.

They are to be served daily, in a clean and proper manner, with two meals of meat soup, the same as we eat ourselves, but it is to be given them separately in two soup-plates. The bread is not to be cut up into the soup, but must be broken into squares about the size of a nut, otherwise they will refuse to eat it. A ration of meat, finely minced, is to be added to it; the whole is then to be mildly seasoned, put into a clean pan, covered close, and carefully simmered before it is dished up. If only one cat should survive, half the sum mentioned will suffice.

MADEMOISELLE DUPUY'S WILL, c.1677

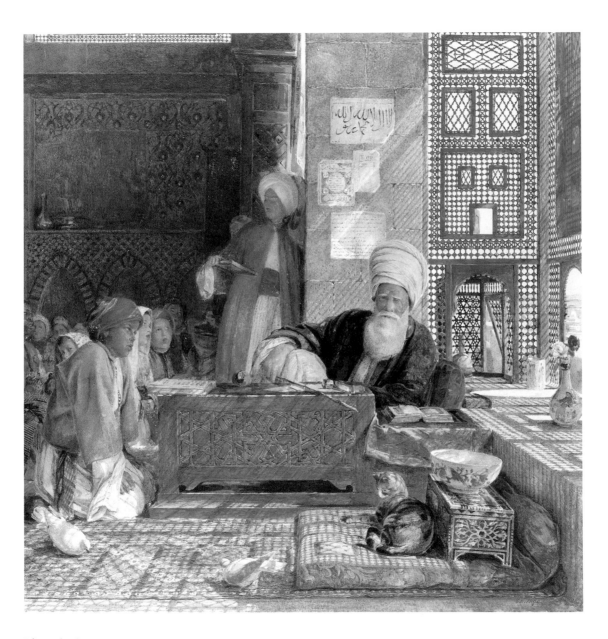

John Frederick Lewis RA, 1805–76 *Interior of a School, Cairo* 1858 Watercolour

THE first day we had the honour of dining at the palace of the Archbishop of Taranto, at Naples, he said to me, 'You must pardon my passion for cats (la mia passione gattesca), but I never exclude them from my dining-room, and you will find they make excellent company.'

Between the first and second course, the door opened, and several enormously large and beautiful cats were introduced, by the names of Pantalone, Desdemona, Otello, and other dramatic *cognomina*. They took their places on chairs near the table, and were as silent, as quiet, as motionless, and as well behaved, as the most bon ton table in London could require. On the Bishop requesting one of the chaplains to help the signora Desdemona to something, the butler stept up to his Lordship and observed, 'Desdemona will prefer waiting for the roast.' After dinner they were sent to walk on the terrace, and I had the honour of assisting at their coucher, for which a number of comfortable cushions were prepared in the Bishop's dressing-room.

On Monsignore Capecelatro, 1744–1836

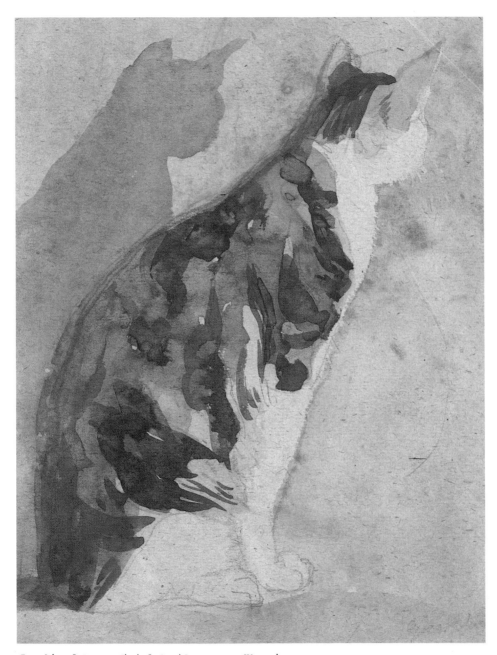

Gwen John, 1876–1939 *Sketch of a Seated Cat* c. 1920 Watercolour

FOR I will consider my cat Jeoffry.
For he is the servant of the living God, duly and daily
serving him.
For in his morning orisons he loves the sun and the sun loves
him.
For he is the tribe of Tiger.
For he will not do destruction, if he is well-fed, neither will he
spit without provocation.
For he purrs in thankfulness, when God tells him he's a good
Cat.
For he is an instrument for the children to learn benevolence
upon.
For every house is incompleat without him and a blessing is
lacking in the spirit.

CHRISTOPHER SMART, 1722–1771 *My cat Jeoffry*

YOU may be reasonably sure when you meet a cat called Ginger or Tigger or merely Puss that his or her owner has insufficient respect for his cat. Such plebeian and unimaginative names are not given to cats by true cat-lovers. There is a world of difference between the commonplace 'Tibby' and the dignified and sonorous 'Tabitha Longclaws Tiddleywinks' which the poet Hood christened his cat. And her three kittens called Pepperpot, Scratchaway and Sootikins reveal an affectionate interest which is never displayed by such ordinary names as Sandy or Micky.

We cannot all rise, of course, to Southey's heights. He, you may remember, called his cat 'the most noble the Archduke Rumpelstiltzchen, Marcus Macbum, Earl Tomlefnagne, Baron Raticide, Waowhler and Scratch.' When summoning His Excellency to a saucer of milk, no doubt 'Rumpel' sufficed, but Southey undoubtedly had the right idea.

MICHAEL JOSEPH, *Charles – The Story of a Friendship* 1943

FLORENCE Nightingale would never travel without her cats, of which she had about sixty. All large Persians, they were named after prominent men of the day, such as Disraeli, Gladstone and Bismarck.

MICHAEL JOSEPH, *Cat's Company* 1946

THE help that England got from Burma in the last war is owed to the cat. The population, as it happened, was deeply influenced by Japanese propaganda against the building of the famous road that was so strategic and indispensable to the Allies. The labourers fled from the yards, to disappear in the impenetrable forest.

It was then that an English colonel, familiar with the beliefs of the people and the folklore of the country, had the idea of having white cats painted on the trucks, jeeps and road-plans. Meanwhile, the English and American airmen had instructions to collect as many white cats as they could find, and as quickly as possible.

The results were not long in appearing. Swiftly the news circulated in the jungle that the aeroplanes had become the refuge and the favoured abode of the sacred felines. From this the natives concluded at once that the gods favoured the Allies, turning a deaf ear to all Japanese offers.

FERNAND MÉRY,
Just Cats 1957

FOLKLORE
AND MYSTERIES

THERE has been at least one weather-prophet cat. His name was Napoleon. He was a white cat, owned by Mrs de Shields of Baltimore, Maryland, U.S.A. He is buried at Rockville, Maryland, and his tombstone bears the inscription 'Napoleon the Weather Prophet, 1917 – 1936.'

It was observed that when rain was coming, Napoleon used to lie prone with his front paws extended and with his head tucked down on to the ground between them. Once, in 1930, there was a long drought. It had lasted more than a month when Napoleon was noticed in the 'rain coming' position. The official weather forecast said 'Continuing dry'. Mrs de Shields rang up a newspaper and said it was going to rain. It did. And for six years Napoleon's weather forecasts were published in the Press. It is said that in all that time he never made a mistake.

BRIAN VESEY-FITZGERALD, *Cats* 1957

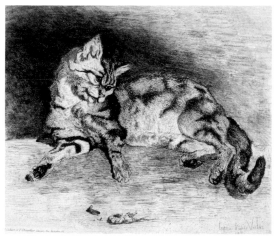

TO Turks dogs are unclean, but cats are in an altogether different category; they are welcome in the house and none of their multitudinous offspring is ever put down. The towns therefore swarm with cats of all sizes, breeds and descriptions, most of them wild and scratching a living from whatever they can find in rubbish heaps and dustbins.

Perhaps Fatty began life as one of these. A tabby, full grown, handsome and obese, we found him one day asleep on our sofa. He was no stray, but evidently preferred our dwelling to his own. In exchange for milk and meat he relentlessly drove away other foraging cats and even attacked the occasional wandering dog.

Ali, our servant, swore he was a holy cat for, lightly impressed on the fur between his ears, were four dark parallel marks.

'You see those marks?' asked Ali. 'One day when the Prophet was saying his prayers, he was disturbed by a mouse playing impiously in front of him. Suddenly a cat removed the mouse. The Prophet was so pleased that he stroked the cat between the ears and his finger-marks never faded. So now we call any cat with those marks a holy cat.'

The Times

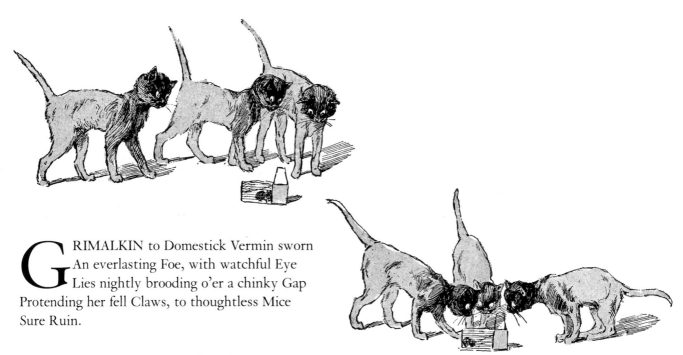

G RIMALKIN to Domestick Vermin sworn
 An everlasting Foe, with watchful Eye
 Lies nightly brooding o'er a chinky Gap
Protending her fell Claws, to thoughtless Mice
Sure Ruin.

JOHN PHILPS, 1676–1709 *The Splendid Shilling*

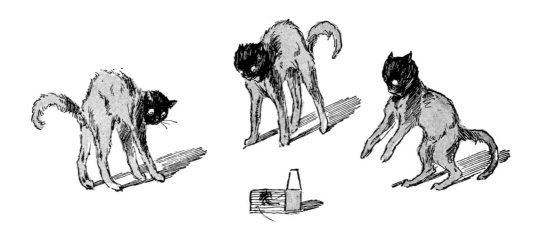

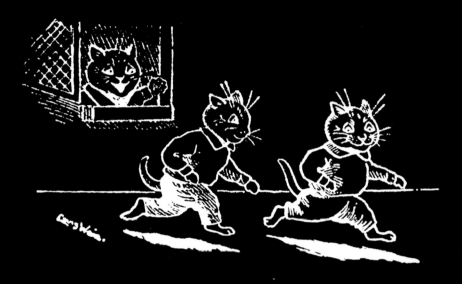

C HEESE modelled in the shape of a cat was formerly
sold in Cheshire, and gave rise to the old saying with
which we are all familiar 'He grins like a Cheshire cat'.

ANNE MARKS *The Cat in History, Legend, and Art* 1909

JUST before the earthquake at Messina, a merchant of that town noticed that his Cats were scratching at the door of his room, in a state of great excitement. He opened the door for them and they flew downstairs and began to scratch more violently still at the street door. Filled with wonder, the master let them out and followed them through the town out of the gates, and into the fields beyond, but, even then, they seemed half mad with fright, and scratched and tore at the grass. Very shortly the first shock of the earthquake was felt, and many houses (the merchant's among them) came thundering in ruins to the ground.

CHAS. H. ROSS, *The Book of Cats* 1868

THE majority of the 'unearthly' behaviour so long attributed to cats is due entirely to their excellently developed senses. They may or may not have a 'sixth' sense, but the five they undoubtedly do have respond much more quickly and efficiently to outside stimuli than the human equivalents can. People puzzle over cat's anticipation of natural events such as storms or earthquakes, or how cats know that their owners are going on holiday. There is no need to resurrect medieval notions of feline magic to explain these things. Cats are basically hunters, even if some of them never exploit their potential, and their bodies and senses are finely attuned to outside events: They can sense a pressure drop, feel miniscule earth tremors, smell far-off rain, observe the break in routine and make provision for their future comfort.

MICHAEL WRIGHT AND SALLY WALTERS, *The Book of The Cat* 1980

HE is a full lecherous beast in youth, swift, pliant and
merry, and leapeth and reseth on everything that is
to fore him: and is led by a straw and playeth
therewith: and is a right heavy beast in age and full sleepy,
and lieth slyly in wait for mice: and is aware where they be
more by smell than by sight, and hunteth and reseth on them
in privy places: and when he taketh a mouse he playeth
therewith, and eateth him after the play. In time of love is
hard fighting for wives, and one scratcheth and rendeth the
other greviously with biting and with claws. And he maketh a
ruthful noise and ghastful, when one proffereth to fight with
another: and unneth is hurt when he is thrown down off an
high place. And when he hath a fair skin, he is as it were
proud thereof, and goeth fast about: and when his skin is
burnt, then be bideth at home, and is oft for his fair skin taken
of the skinner and slain and flayed.

BARTHOLOMEUS ANGLICUS, *De Proprietatibus Rerum* c. 1260

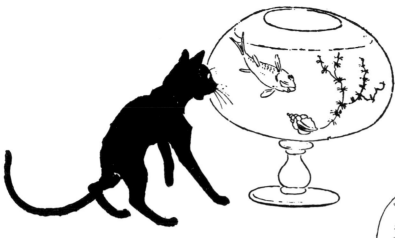

NOTHING is more contrary to the nature of a Cat, then is wet and water, and for this cause came the proverb that they love not to wet their feet. It is a neat and cleanly creature, oftentimes licking her own body to keep it neat and fair, having naturally a flexible back for this purpose, and washing her face with her forefeet: but some observe, that if she put her feet beyond the crown of her head, that it is a presage of rain, and if the back of a Cat be thin the beast is of no courage or valew.

EDWARD TOPSELL,
The History of Four-footed Beasts
1607

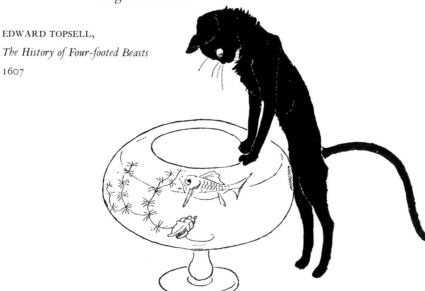

IN September 1850, the mistress of a public house in the Commercial Road, London, going late at night into the tap-room, found her cat in a state of great excitement. It would not suffer itself to be stroked, but ran wildly, to and fro, between its mistress and the chimney-piece, mewing loudly. The landlady, alarmed, summoned assistance, and presently a robber was discovered up the chimney.

Upon his trial it was proved that he had robbed several public houses, by remaining last in the tap-room, and concealing himself in a similar manner.

CHAS. H. ROSS, *The Book of Cats* 1868

NOAH, sailing o'er the seas
 Ran fast aground on
 Ararat,
His dog then made a spring and
took
 The tail from off a pretty cat;
Puss through the window quick did
fly,
 And bravely through the waters
swam
Nor ever stopped till high and dry,
 She landed on the Calf of Man.
Thus tailless Puss earned Mona's
thanks
 And ever after was called Manx.

ANON

AT this period of his life Dumas Alexandre the Elder lived with his mother and the cat Mysouff in the Rue de l'Ouest, and acted as a clerk under Louis Philippe, Duc d'Orléans. The office was in the Rue St Honoré, half an hour's walk from Dumas' home, and every morning Mysouff accompanied his master as far as the Rue de Vaugirard, and every afternoon he went again to the same spot to meet and conduct him home, with affectionate welcome.

The extraordinary part of this performance was that if by chance any unforeseen circumstance caused Dumas to vary from his usual time of return, it was useless for his mother to open the door. Mysouff would not stir from his cushion. But when Dumas was faithful to his wonted hour, if she forgot to let Puss out, he would scratch the door until she released him. Therefore she called Mysouff her barometer; it was set fair when Dumas came home to dine, but stormy when he failed to appear.

M. OLDFIELD HOWEY, *The Cat in the Mysteries of Religion and Magic* 1931

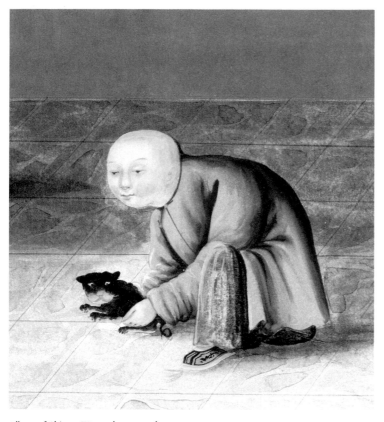

Album of Chinese Watercolours 19th century

IN Japan, cats are most particularly venerated after their deaths. In Tokyo, they have their own temple, the temple of Go-To-Ku-Ji. It is small in size, but perfectly proportioned, and concealed by foliage. It is typically Japanese, both in style and in the material used, which is crossed battens of wood. It opens with a great doorway, a kind of lattice barrier, flanked on both sides by two less conspicuous, bell-shaped entrances.

This temple is served by priests who wear sacred vestments and intone gentle religious chants for the repose of these small feline souls.

At the heart of the temple, on the altar, appears the most astonishing assembly of cats, sculptured, painted and carved in relief. Cats on cloth and paper, in porcelain and bronze. There they are crowded one against the other, frozen motionless and mounting guard. And each one has its small right paw curiously raised to the height of its eyes as if to greet the visitor or attract his attention. This is the classic way of representing 'Maneki-Neko', the small female cat who lures and enchants people, brings happiness and ensures good luck.

FERNAND MÉRY, *The Life, History and Magic of The Cat* 1967

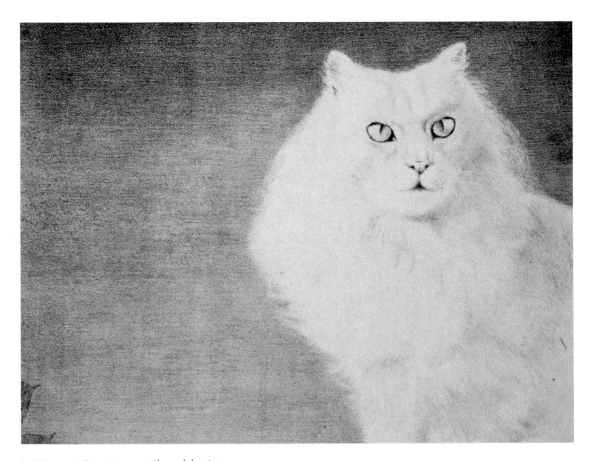

H W Keen *White Cat* 1925 Charcoal drawing

SHE moved through the garden in glory because
She had very long claws at the end of her paws.
Her back was arched, her tail was high,
A green fire glared in her vivid eye;
And all the Toms, though never so bold,
Quailed at the martial Marigold.

RICHARD GARNETT, 1835–1906 *Marigold*

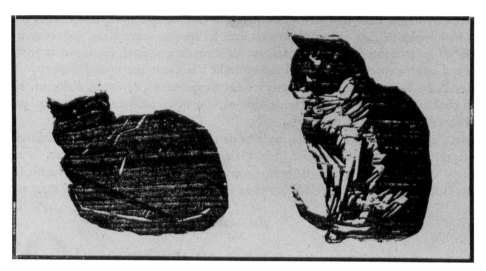

AMONG the other important and privileged members of the household who figured in attendance at dinner was a large grey cat, who, I observed, was regaled from time to time with tit-bits from the table. This sage grimalkin was a favourite of both master and mistress, and slept at night in their room, and Scott laughingly observed, that one of the least wise parts of their establishment was, that the window was left open at night for puss to go in and out. The cat assumed a kind of ascendancy among the quadrupeds – sitting in state in Scott's armchair, and occasionally stationing himself on a chair beside the door, as if to review his subjects as they passed, giving each dog a cuff beside the ears as he went by. This clapper-clawing was always taken in good part; it appeared to be, in fact, a mere act of sovereignty on the part of grimalkin, to remind the others of their vassalage; which they acknowledged by the most perfect acquiescence. A general harmony prevailed between sovereign and subjects, and they would all sleep together in the sunshine.

WASHINGTON IRVING, *Abbotsford and Newstead Abbey* 1850

CAT! who has pass'd thy grand climacteric,
 How many mice and rats hast in thy days
 Destroy'd? – How many tit bits stolen? Gaze
With those bright languid segments green, and prick
Those velvet ears – but pr'ythee do not stick
 Thy latent talons in me – and upraise
 Thy gentle mew – and tell me all thy frays
Of fish and mice, and rats and tender chick.
Nay, look not down, nor lick thy dainty wrists –
 For all the wheezy asthma, – and for all
Thy tail's tip is nick'd off – and though the fists
 Of many a maid have given thee many a maul,
Still is that fur as soft as when the lists
 In youth thou enter'dst on glass bottled wall.

JOHN KEATS, 1793–1821 *To a cat*

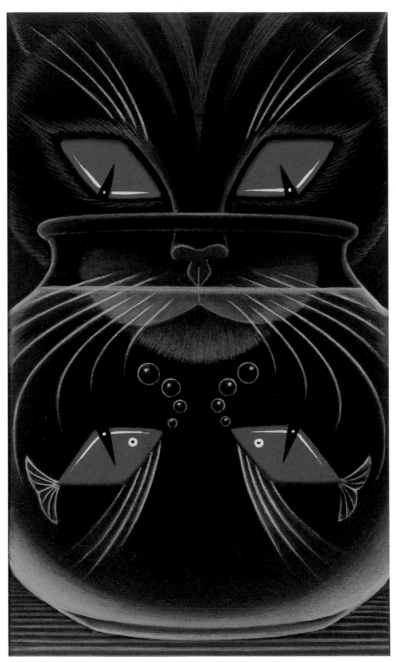

Tony Meeuwissen *The Four of Diamonds* 1986
© Nicholas Dawe, Folio, London

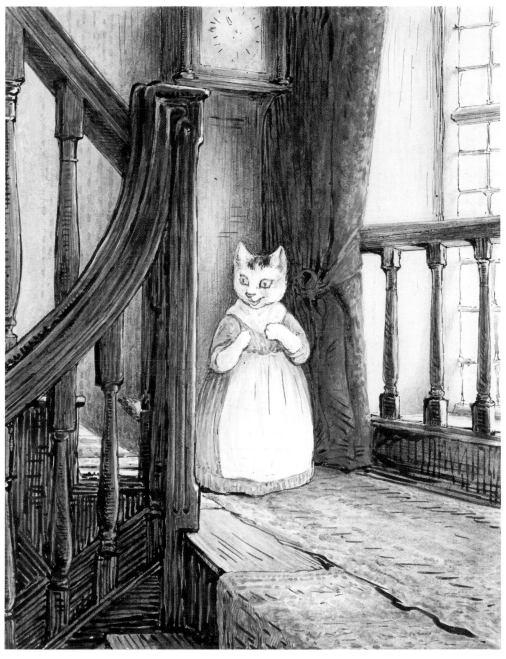

Beatrix Potter 1866–1943 *Tabitha Twitchit on the landing*
Watercolour Reproduced by permission of Frederick Warne & Co.

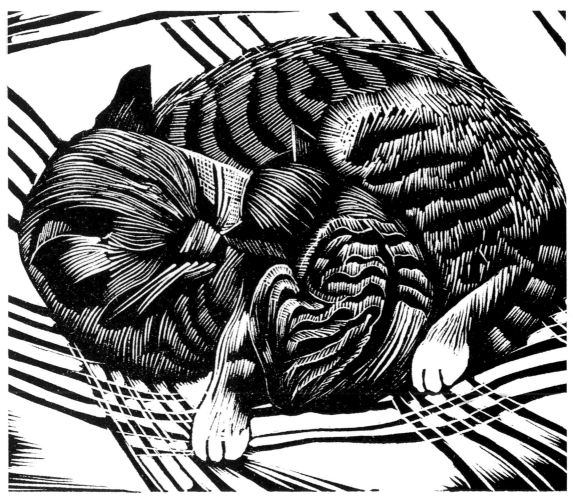

John Nash, 1893–1977 *Cat and Kitten* 1928 Woodcut

BEAUTIFUL present sufficingness of a cat's imagination! Confined to the snug circle of her own sides, and the two next inches of rug or carpet.

LEIGH HUNT 1784–1859

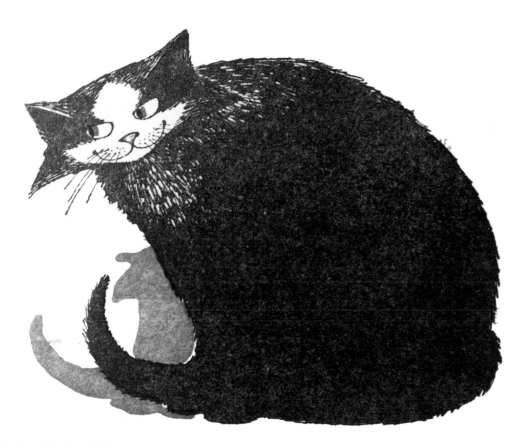

Taken from the Renier Collection c. 1930

CATS are a mysterious kind of folk. There is more passing in their minds than we are aware of.

SIR WALTER SCOTT 1771–1832

Beatrix Potter, 1866–1943 From *The White Cat* Watercolour
Reproduced by permission of Frederick Warne & Co.

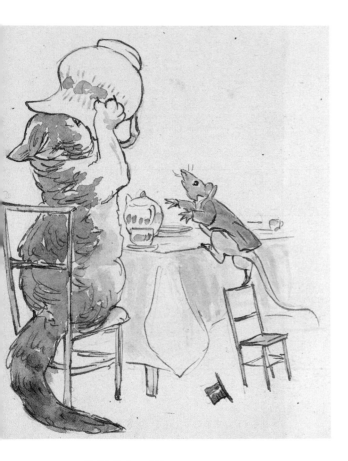

Beatrix Potter, 1866–1943
From *The Sly Old Cat*
Watercolour
Reproduced by permission
of Frederick Warne & Co.

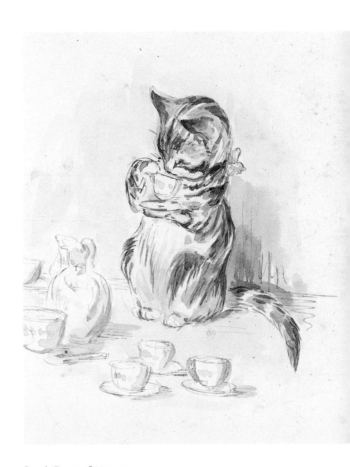

Beatrix Potter, 1866–1943
Miss Moppet drinking Tea
Watercolour
Reproduced by permission
of Frederick Warne & Co.

MOST cats like music of some sort, but the sort depends upon the taste of the individual cat. I have known a cat that adored the organ, and would always come into the village church when the organ was being played. I have known another that simply hated the harmonium, and would always leave the house – not just the room – until the practice was over. Most cats, however, seem to like the violin and the piano, and some cats develop a passion for running up and down the keys of a piano. I believe that all cats with normal hearing have a fondness for one particular note, and that it is, once this note has been found, a simple matter to get them to come to it. Many cat-owners have trained their cats in this way. The silent dog-whistle is as valuable for cats as it is for dogs.

BRIAN VESEY-FITZGERALD, *Cats* 1957

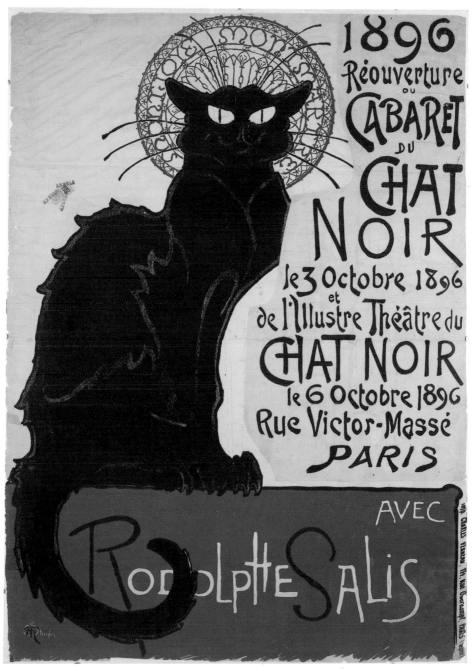

Steinlen, 1859–1923 *Le Chat Noir* Colour lithograph

IF I were a dog, cats would make me furious. For impudence and provocation an intelligent cat is hard to beat. I have watched Minna coiled up on a wall just a very few inches out of reach of an excited, barking dog. She knew perfectly well that the wall was tantalizingly out of any dog's range. The agitated brute would tire himself jumping up at her, but although his paws might scratch the wall a mere two or three inches below her resting-place she was supremely indifferent. Her only acknowledgment of the dog's presence was a disdainful turning aside of her head, to make it plain that she did not care for the proximity of coarse, doggy breath. Only when the exhausted dog gave up the chase and went off to find a consoling bone would Minna Minna Mowbray get up, languidly stretch her shapely limbs and proceed with the business of the day.

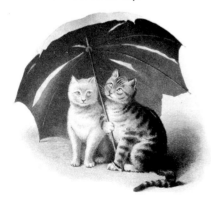

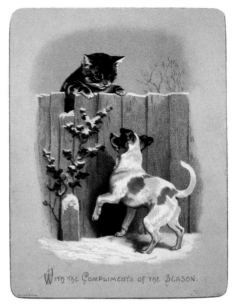

Christmas card c. 1885 Colour lithograph

IN every cat and dog friendship I have observed at least a trace of condescension on the part of the cat. Even kittens do not let their love of play obscure their sense of inborn superiority; and as for a grown-up cat deigning to play with a puppy, nothing could be more patronizing. A few taps with a closed paw is the friendly warning usually given by a cat to a too-boisterous dog, followed promptly by a scratch if his antics become too rough for feline taste. Most cats are willing to tolerate dogs, I have found, and sometimes the relationship will develop into friendship, always however with certain reservations on the part of the cat.

MICHAEL JOSEPH, *Cat's Company* 1946

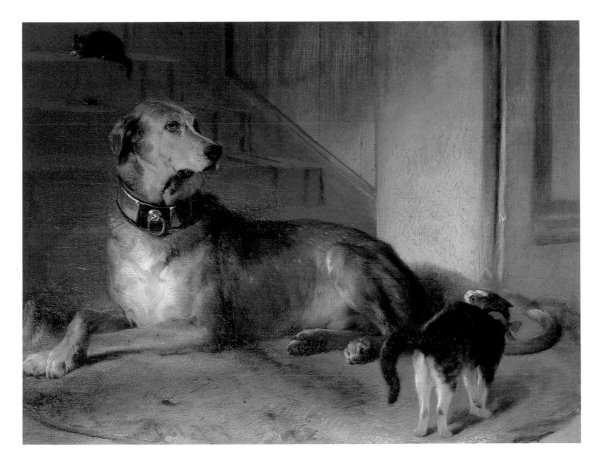

Sir Edwin Landseer, 1802–1873 *The Barrier* 1832 Oil on canvas

THE TEN COMMANDMENTS OF THE GENTLEMAN CAT

I A Gentleman Cat has an immaculate shirt front and paws at all times.

II A Gentleman Cat allows no constraint of his person, even loving constraint.

III A Gentleman Cat does not mew except in extremity. He makes his wishes known and waits.

IV When addressed, a Gentleman Cat does not move a muscle. He looks as if he hadn't heard.

V When frightened, a Gentleman Cat looks bored.

VI A Gentleman Cat takes no interest in other people's affairs, unless he is directly concerned.

VII A Gentleman Cat never hurries towards an objective, never looks as if he wanted just one thing: it is not polite.

VIII A Gentleman Cat approaches food slowly, however hungry he may be, and decides at least three feet away whether it is Good, Fair, Passable, or Unworthy. If Unworthy, he pretends to scratch earth over it.

IX A Gentleman Cat gives thanks for a Worthy meal, by licking the plate so clean that a person might think it had been washed.

X A Gentleman Cat is never hasty when choosing a housekeeper.

MAY SARTON, *The Fur Person* 1957

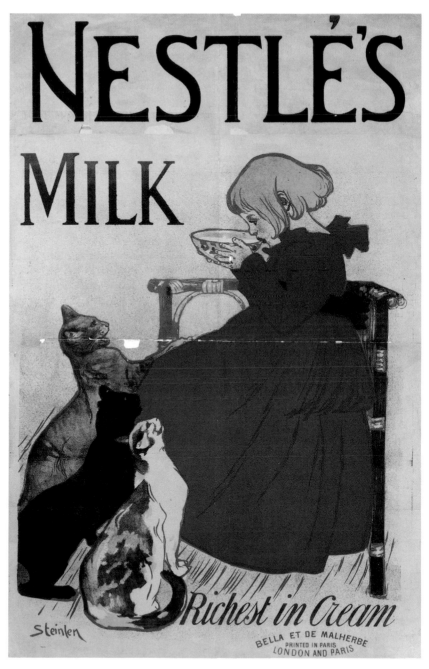

Steinlen, 1859–1923 Advertisement for Nestlé's milk c. 1900 Colour lithograph

I have (and long shall have) a white great nimble cat,
A king upon a mouse, a strong foe to the rat,
Fine eares, long taile he hath, with Lions curbed clawe,
Which oft he lifteth up, and stayes his lifted pawe,
Deepe musing to himselfe, which after-mewing showes,
Till with lickt beard, his eye of fire espie his foes.

SIR PHILIP SIDNEY, *Second* 🪰 *Eclogues of Arcadia*
1554–1586

IT may seem funny, but my cat
Is learning English. Think of
that!
For years she did all right with
'Meow',
But that won't satisfy her now,
And where before she'd squawk or
squeak
She'll try with all her might to
speak.
So when I came downstairs today
I was impressed to hear her say
'Hallo'. Not like a person, true;
It might not sound quite right to
you,
More of a simple squeak or
squawk –
Still, that's what happens when
cats talk:
Their mouths and tongues and
things are fine
But different shapes from yours and
mine;
They simply try their level best
And our good will must do the rest.
So when I pick up Sarah's dish
And ask who's for a spot of fish,
I have to listen carefully,
But I've no doubt she answers 'Me!'
And when I serve her with the stuff

It's 'Ta' she tells me, right enough.
Well now, I could go on about
Her call of 'Bye!' when I go out
and 'Hi!' when I come home again,
But by this stage the point is plain:
If you've a sympathetic ear
Cat-English comes through loud
and clear;
Of course, the words are short and
few,
The accents strange, and strident
too,
And our side never gets a crack
At any kind of answer back,
But think of it the other way,
With them to listen, you to say.
Imagine the unholy row
You'd make with 'Mew!' and 'Purr!'
and 'Meow!'
And not get anything across!
Sarah would give her head a toss,
Her nose or tail a scornful twitch –
I really cannot settle which –
And gaze at you in sad distress
For such pathetic childishness.
Unless you want a snub like that
Leave all the talking to your cat.

KINGSLEY AMIS,
Cat-English 1988

THE DEVOTED COMPANION

MY smoke Persian would only come in by a certain window. If it were closed she would not try to attract attention, but disappear in the long London back gardens again.

One very cold spring day I was enduring the draught, and was glad to hear the thump as she landed on the floor. Instead of coming into the kitchen for her supper, she remained in the passage, calling to me with little throaty croons and chirrups. I went to her expecting to be offered a mouse or a bird. She dropped at my feet a small white egg, probably a small pullet's, or pigeon's.

It was quite whole except for one tiny tooth mark. When I picked it up she gave a pleased mew and ran off to her dinner. It was Easter.

Letter to Country Life

MY friend had a little helpless leveret brought to him, which the servants fed with milk in a spoon, and about the same time his cat kittened and the young were despatched and buried. The hare was soon lost, and supposed to be gone the way of most fondlings, to be killed by some dog or cat. However, in about a fortnight, as the master was sitting in his garden in the dusk of the evening, he observed his cat, with tail erect, trotting towards him, and calling with little short inward notes of complacency, such as they use towards their kittens, and something gambolling after, which proved to be the leveret that the cat had supported with her milk, and continued to support with great affection.

GILBERT WHITE, *The Natural History of Selborne* 1776

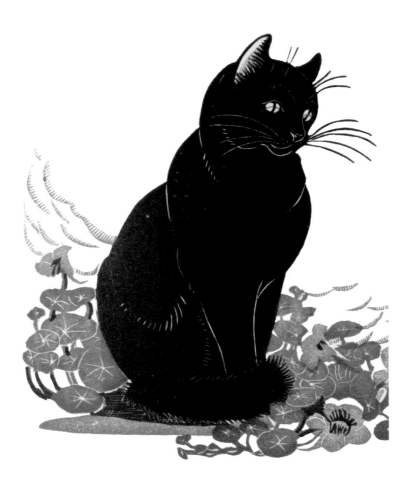

TO WILLIE
WHO LIVES IN A WORLD I CANNOT ENTER
AND KNOWS MANY THINGS BEYOND MY PERCEPTION,
WHOSE DEMANDS ARE PARAMOUNT,
AND WHO ALONE INTERRUPTS MY WORK AS PLEASES HIM,
FOR HE SPEAKS ALWAYS WITH LOVE
IN PIANISSIMO PURRS AND MUTED MEOWS

RAYMOND BUSHELL, *The Inro Handbook* 1979

THEY both of them sit by my fire every evening and wait with Impatience; and at my Entrance, never fail of running up to me, and bidding me Welcome, each of them in its proper Language. As they have been bred up together from Infancy, and have seen no other Company, they have acquired each other's Manners; so that the Dog gives himself the Airs of a Cat, and the Cat, in several of her Motions and Gestures, affects the Behaviour of the little Dog.

RICHARD STEELE, 1672–1729

MY wife was lying in bed with influenza in our little Chelsea house, and I was sitting on it making suitable noises of sympathy, when in came Benedict, carrying a small bunch of hothouse grapes in his mouth, and jumped up on the bed covers to deposit them in front of my wife, just as I might have done had I any money. However, it transpired that Benedict had none either and had not been out to the fruiterers in the King's Road, but had in some mystical fashion cottoned on to the fact that the etiquette of sick-visiting calls for the presentation of grapes. He had in fact collected them from the sideboard in the dining-room and without prompting carried them up two flights of stairs.

But then you may remember the tale of Dr Johnson's famous cat, who appeared in the dining-room at Crown Court one day with two mice it had caught and put one of them on Dr Johnson's place and one on its own at the other end of the table. The moral is simple. If you look after your cat, it will look after you.

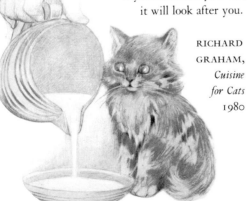

RICHARD GRAHAM, *Cuisine for Cats* 1980

WHEN I am playing with my cat, who knowes whether she have more sport in dallying with me, than I have in gaming with her? We entertaine one another with mutuall apish trickes. If I have my houre to begin or to refuse, so hath she hers.

M. E. DE MONTAIGNE 1533–1592

A slovenly cat was James, as ever I saw. Pippa, who will wash herself from ears to tail after eating the tail of a sardine, could never understand the fine carelessness of the male. I have seen her, in distress over his slovenliness, turn to and wash James and sleek out his fur. James bore her with humour; at such times his eye was like the eye of a man who is having his white tie properly tied for him by female hands. Hardy he was and brave; a more amiable warrior I have never known. His purr, when he purred for sheer happiness of life, was as the purr of many kettles. Now he is dead, and I remember James with sorrow. His widow goes in rich black, like many another widow, and seems consoled.

OSWALD BARRON, 1868–1939 *Day in and Day out*

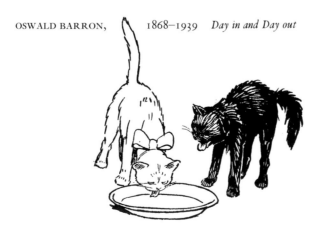

A house without a cat, and a well-fed, well-petted, and properly revered cat, may be a perfect house, perhaps, but how can it prove its title?

MARK TWAIN, 1835–1910

'HIS capacity receiveth as the sea.' Not for him the unfelicitous trait of being unable to take too much attention; not for him the sudden bite and claw and furious oscillation of the tail when the strain of being loved gets too great. This round cat is the endless welcome, entirely tolerant. Pick him up, put him down, let him in, throw him out, feed him, refuse him food: all is fine with him.

What cat in the world purrs like a motorbike when you push him through the back door into a snowstorm in December? This one does. Gratitude altogether overwhelms circumstance. In such a complete lack of criticism, such an abandonment of judgement in favour of sheer, inexhaustible appreciativeness, perhaps just a mite stupid? Well . . . yes . . . maybe just a *mite* stupid. I shall have to admit that intellectual acuity *is* more potential than evidence in the ginger cat – just as physical nimbleness (natural to most cats) is not his strongest point. He thunders, herdlike, across a room or a field to greet one, or jumps like a hundredweight of potatoes off a table. His brand of tenderness is definite, bold, unremitting, unsubtle, heavy, and meant. It is not delicate. But good heavens, this solid mass of warmth and daftness certainly makes you feel as though you matter.

The Christian Science Monitor

WHEREVER a cat sits, there shall happiness be found.

STANLEY SPENCER, 1891–1959

THE BEAUTY
OF THE CAT

THAT crafty cat, a buff-black Siamese,
Sniffing through wild wood, sagely, silently goes –
Prick ears, lank legs, alertly twitching nose –
And on her secret errand reads with ease
A language no man knows.

WALTER DE LA MARE, 1873–1956 *Double Dutch*

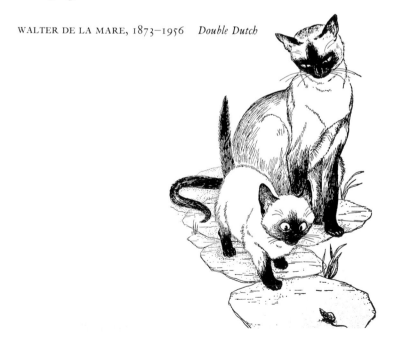

IT was a little captive cat
 Upon a crowded train
 His mistress takes him from
his box
 To ease his fretful pain.

She holds him tight upon her knee
 The graceful animal
And all the people look at him
 He is so beautiful.

But oh he pricks and oh he prods
 And turns upon her knee
Then lifteth up his innocent voice
 In plaintive melody.

He lifteth up his innocent voice
 He lifteth up, he singeth
And to each human countenance
 A smile of grace he bringeth.

He lifteth up his innocent paw
 Upon her breast he clingeth
And everybody cries, Behold
 The cat, the cat that singeth.

He lifteth up his innocent voice
 He lifteth up, he singeth
And all the people warm
themselves
 In the love his beauty bringeth.

STEVIE SMITH, 1902–1971
The singing cat

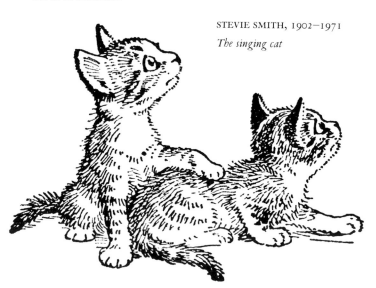

SEE the Kitten on the wall,
Sporting with the leaves that
fall,
Withered leaves – one – two – and
three –
From the lofty elder-tree!
Through the calm and frosty air
Of this morning bright and fair,
Each invisible and mute,
In his wavering parachute.

– But the Kitten, how she starts,
Crouches, stretches, paws, and
darts!
First at one, and then its fellow,
Just as light and just as yellow;
There are many now – now one –
Now they stop and there are none:
What intenseness of desire
In her upward eye of fire!

With a tiger-leap half-way
Now she meets the coming prey,
Lets it go as fast, and then
Has it in her power again:
Now she works with three or four,
Like an Indian conjurer;
Quick as he in feats of art,
Far beyond in joy of heart.

WILLIAM WORDSWORTH, 1770–1850
The kitten and falling leaves

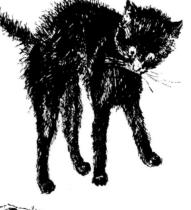

NO experiment can be more beautiful than that of setting a kitten for the first time before a looking-glass. The animal appears surprised and pleased with the resemblance, and makes several attempts at touching its new acquaintance; and, at length, finding its efforts fruitless, it looks behind the glass, and appears highly surprised at the absence of the figure: it again views itself; tries to touch it with its foot; suddenly looking at intervals behind the glass, it then becomes more accurate in its observations, and begins, as it were, to make experiments, by stretching out its paw in different directions; and when it finds that these motions are answered in every respect by the figure in the glass, it seems, at length, to be convinced of the real nature of the image. The same is the case with the Dog at an early age.

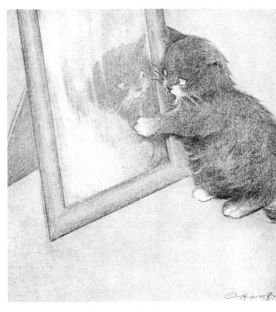

THE sleep of the Cat, though generally very light, is, however, sometimes so profound, that the animal requires to be shaken pretty briskly before it can be awakened. This particularity takes place chiefly in the depth of winter, and especially on the approach of snowy weather. At such periods also, as well as some others, the animal diffuses a fragrant smell somewhat like that of cloves.

REV. W. BINGLEY, 1813–1879

The Lodge, Nov. 10th, 1787

I have a kitten, my dear, the drollest of all creatures that ever wore a cat's skin. Her gambols are not to be described, and would be incredible, if they could. In point of size she is likely to be a kitten always, being extremely small of her age, but time I suppose, that spoils everything, will make her also a cat. You will see her I hope before that melancholy period shall arrive, for no wisdom that she may gain by experience and reflection hereafter will compensate the loss of her present hilarity. She is dressed in a tortoise-shell suit, and I know that you will delight in her.

WILLIAM COWPER, 1731–1800

THE kitten's adroitness grow with him. At two months he can leap like a ballerina, to seize the curtain cords or reach the rabbit's foot hung at the end of a string from the door-knob. Mousing is really too simple now. He practises jumping, to be able to catch birds in flight. He lifts latches, opens doors.

FERNAND MÉRY, *Just Cats* 1957

TRY holding the tip of a cat's tail up to his face. He will immediately wash it. Normally he can't hold it firmly enough. It worries him to know it never gets washed.

Given this opportunity, he makes a very thorough job of it.

Journal of The Cats' Protection League

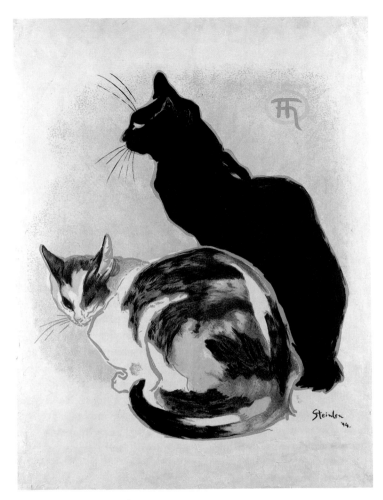

Steinlen, 1859–1923 *Two Cats* c. 1900

THOSE who love cats which do not even purr,
 Or which are thin and tired and very old,
 Bend down to them in the street and stroke their fur
And rub their ears and smooth their breast, and hold
Their paws, and gaze into their eyes of gold.

FRANCIS SCARFE

Scrap c. 1900 Colour lithograph

22nd. About three o'clock this morning I waked with the
noise of the rayne, having never in my life heard a more
violent shower; and then the cat was lockt in the chamber,
and kept a great mewing, and leapt upon the bed, which made
me I could not sleep a great while.

SAMUEL PEPYS, 1633–1703

FOSS the cat, having taken to sit from 5 to 8 AM under the cage of George's blackbird, since that very charming animal took to singing, we had very great hope of our cat's aesthetic tendencies, and had expected eventually to hear poor dear Foss warble effusively. But alas! it has been discovered that there is a hole in the lower part of Merlo's cage, and Foss's attention relates to pieces of biscuit falling through.

EDWARD LEAR, 1812–1888

THE difference between a cat and a dog is that the dog may be talked over and made to see reason without much trouble. A cat, on the other hand, has a bloody-minded outlook. It thinks the world owes it a living. It treats lectures with indifference. It turns a deaf ear. It makes a rude gesture by showing its rear and stalking away. It thinks it is a tiger. I suspect it only understands violence. How else can I account for the fact that this impudent intruder takes my food and ruins my labour? A man can talk to a horse, a dog or even a bird, but there is no reasoning with a cat.

IAN NIALL in *Country Life*

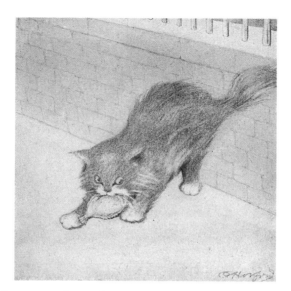

THE cat has a discriminating appetite. He would rather steal a lobster at the risk of having a saucepan lid thrown at him than fill his belly with bread and milk from his own dish.

MICHAEL JOSEPH, *Charles – The Story of a Friendship* 1943

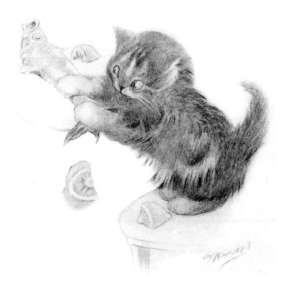

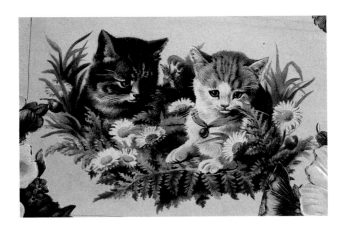

YOU can buy wonderful and handsome cat beds. You can buy special mattresses for cat beds. You can buy beautifully upholstered and embroidered cat cushions and pillows, and lovely fleecy blankets with the pet's name in the corner. Lots of people do. It is quite unnecessary. The plain fact is that, given the choice, cats prefer to sleep on newspaper. If they cannot get newspaper and are given the choice, then they will choose to sleep on almost anything in preference to a cat bed.

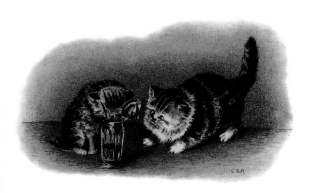

I never knew but one dog that would open a door by moving the fastening without being shown or taught how to do it. Cats that have done so are numberless. I noticed one at the last Crystal Palace Show, a white cat: it looked up, it looked down, then to the right and then a little to the left, paused, seemed lost in the thought, when, not seeing any one about, it crept up to the door, and with its paw tried to pull back the bolt or catch. On getting sight of me, it retired to a corner of the cage, shut its eyes, and pretended to sleep. I stood further away, and soon saw the paw coming through the bars again. This cat had noticed how the cage-door was fastened, and so *knew* how to open it.

BRIAN VESEY-FITZGERALD *Cats* 1957

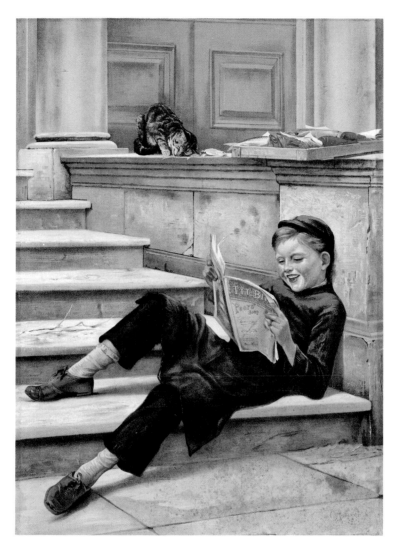

Advertisement for *Tit-Bits* magazine
Signed by C Amyot c. 1900 Colour lithograph

From the Renier Collection c.1930

SIR – In this age of high power technology and know-how, it seems strange that, to my knowledge, there does not yet exist an infallible way of keeping cats out of my garden.

To date I have spent a small fortune on expensive proprietory cat repellants, scattered old-fashioned cat-pepper with a lavish hand, hung moth-balls in the hedges and (apparently an infallible remedy) placed cartons filled with cement and sand mixed with ammonia.

Each new ploy is greeted by my feline visitors with the utmost enthusiasm, the wire netting I spread on the ground is an enjoyable trampoline, the varying odours are inhaled with pleasure. They can hardly wait for the next treat I have in store for them. Meanwhile my flower-beds, plants and birds suffer.

Have readers any valuable suggestions?

The Times

A dog will often steal a bone,
But conscience lets him not alone,
And by his tail his guilt is known.

But cats consider theft a game,
And, howsoever you may blame,
Refuse the slightest sign of shame.

When food mysteriously goes,
The chances are that Pussy knows
More than she leads you to suppose.

And hence there is no need for you,
If Puss declines a meal or two,
To feel her pulse and make ado.

ANON

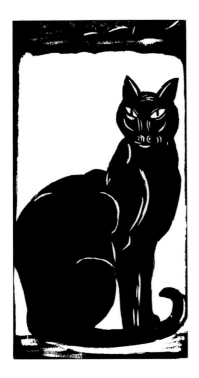

Omega Workshop
Black Cat c. 1912

IN the midst of the clamour Tobermory entered the room and made his way with velvet tread and studied unconcern across to the group seated round the tea-table.

A sudden hush of awkwardness and constraint fell on the company. Somehow there seemed an element of embarassment in addressing on equal terms a domestic cat of acknowledged dental ability.

'Will you have some milk, Tobermory?' asked Lady Blimley in a rather strained voice.

'I don't mind if I do,' was the response, couched in a tone of even indifference. A shiver of suppressed excitement went through the listeners, and Lady Blemley might be excused for pouring out the saucerful of milk rather unsteadily.

'I'm afraid I've spilt a good deal of it,' she said apologetically.

'After all, it's not my Axminster,' was Tobermory's rejoinder.

Another silence fell on the group, and then Miss Resker, in her best district-visitor manner, asked if the human language had been difficult to learn. Tobermory looked squarely at her for a moment and then fixed his gaze serenely on the middle-distance. It was obvious that boring questions lay outside his scheme of life.

'Would you like to go and see if cook has got your dinner ready?' suggested Lady Blemley hurriedly, affecting to ignore the fact that it wanted at least two hours to Tobermory's dinner-time.

'Thanks,' said Tobermory, 'not quite so soon after my tea. I don't want to die of indigestion.'

'Cats have nine lives, you know,' said Sir Wilfrid heartily.

'Possibly,' answered Tobermory; 'but only one liver.'

SAKI (H H Monro), 1870–1916
Tobermory

Sir John Tenniel, 1820–1914 *The Black Kitten*

THE way Dinah washed her children's faces was this: first she held the poor thing down by its ear with one paw, and then with the other paw she rubbed its face all over, the wrong way, beginning at the nose: and just now she was hard at work on the white kitten, which was lying quite still and trying to purr – no doubt feeling that it was all meant for its good.

But the black kitten had been finished with earlier in the afternoon, and so, while Alice was sitting curled up in a corner of the great armchair, half talking to herself and half asleep, the kitten had been having a grand game of romps with the ball of worsted Alice had been trying to wind up, and had been rolling it up and down till it had all come undone again; and there it was, spread over the hearth-rug, all knots and tangles, with the kitten running after its own tail in the middle.

LEWIS CARROLL, 1832–1898 *Alice Through the Looking Glass*

MY name is Tough Tom,
And I am King of the Car Park.
When the sun shines
It warms the hoods of the cars for us.
We like that.
We lie on them.
Sometimes we get chased because
We leave footmarks on the cars,
But most of the time nobody bothers,
We have our own crowd that comes here
To sun.
But I say who does and who doesn't.
See?
Because I'm King of the Car Park.

PAUL GALLICO, 1898–1976 *The Ballad of Tough Tom*

Felix and the mouse after Pat Sullivan 1924
Calico Printers Association Cotton

LIST OF MONOCHROME ILLUSTRATIONS

PAGES 7, 9, ,11, 12, 34, 40, 42, 43, 49, 62, 71, 74, 75, 89 drawings taken from *Des Chats – Images sans Paroles by Steinlen c. 1890*

PAGES 36, 68, 76, 77, 78, 84, 85 taken from *A Kitten's Garden of Verses* by Oliver Herford, 1911 and the *Rubaiyat of a Persian Kitten* by Oliver Herford, 1905

PAGES 18, 28, 58, 70, 80, 86 taken from *A Peep into Catland*, illustrated by Constance Howell, 1890

PAGE 89 drawing by Louis Wain, 1860–1939

PAGE 64 drawing by Sir John Tenniel, 1820–1914

All other monochrome illustrations taken from the Renier Collection of children's books. Bethnal Green Museum of Childhood (a branch of the Victoria and Albert Museum)

Reprinted by permission of Faber & Faber Ltd from *Old Possum's Book of Practical Cats*.

The Tailor of Gloucester & *The Tale of Samuel Whiskers* reprinted by permission of Frederick Warne & Co.

Excerpts reprinted by permission of the *Evening Standard*.

Excerpts from *Cat's Company* and *Charles — The Story of a Friendship* reprinted by permission of Michael Joseph.

© 1988 Kingsley Amis. Reprinted by permission Jonathan Clowes Ltd, London on behalf of Kingsley Amis.

Excerpts reprinted by permission of *Country Life*.

Poem reprinted by permission of James MacGibbon, executor of the estate of Stevie Smith, and *The Collected Poems of Stevie Smith*.

Reprinted from *The Collected Poems 1909–1939* © William Carlos Williams, represented in the UK by Carcanet Press Ltd.

Reprinted by permission of the Literary Trustees of Walter de la Mare and the Society of Authors as their representative.

Reprinted by permission of the representatives of Paul Gallico.

Beatrix Potter: *Miss Moppet drinking tea* (Ref 1275): Copyright © Frederick Warne & Co. 1985

Two illustrations from *The White Cat* (Ref 985 a, b): Copyright © Frederick Warne & Co. 1955

The Sly Old Cat drinking milk (Ref 1027): Copyright © Frederick Warne & Co. 1971

Mrs Tabitha Twitchit on the landing (Ref 787): Copyright © Frederick Warne & Co. 1955

REFERENCES

▲▲▲▲▲▲▲▲▲▲▲▲▲▲▲▲▲▲▲▲▲▲▲▲▲▲▲▲▲▲▲▲▲▲▲▲▲▲▲

T S Eliot *Old Possum's Book of Practical Cats* 1939 Faber & Faber

Beatrix Potter *The Tailor of Gloucester* 1903 Frederick Warne & Co

Lewis Carroll *Alice in Wonderland* 1865 Macmillan

Beatrix Potter *The Tale of Samuel Whiskers* 1908 Frederick Warne & Co Ltd

Mike Sayer *The Cat-Lover's Bedside Book* 1974 Batsford

The Rev W B Daniel *Supplement to the Rural Sports* Published 1812–13

Mrs Pitt Byrne *Curiosities of the Search Room* 1677

Lady Morgan *Book of the Boudoir* c.1800

Michael Joseph *Charles – The Story of a Friendship* 1943 Michael Joseph

Michael Joseph *Cat's Company* 1946 Michael Joseph

Fernand Méry *Just Cats* 1957 Souvenir Press

Anne Marks *The Cat in History, Legend and Art* 1909 Elliot Stock

Michael Wright and Sally Walters *The Book of the Cat* 1980 Pan Books

M Oldfield Howey *The Cat in the Mysteries of Religion & Magic* 1931 David McKay & Co

Fernand Méry *The Life, History and Magic of the Cat* 1967 Hamlyn

May Sarton *The Fur Person* 1957 Frederick Muller

Raymond Bushell *The Inrō Handbook* 1979 Weatherhill

Richard Graham *Cuisine for Cats* 1980 Pedigree Books

M E de Montaigne *The Enigmatic Cat* from an essay on Raymond Sebond 1603

Stevie Smith *The Complete Poems of Stevie Smith* published 1975 Penguin

Saki (H H Monro) *Short Stories* 1965 Dent

Lewis Carroll *Alice Through the Looking Glass* 1871 Macmillan

Edward Topsall *History of Four-Footed Beastes* published 1607

Brian Vesey-Fitzgerald *Cats* 1957 Penguin